# Techniques of Drawing

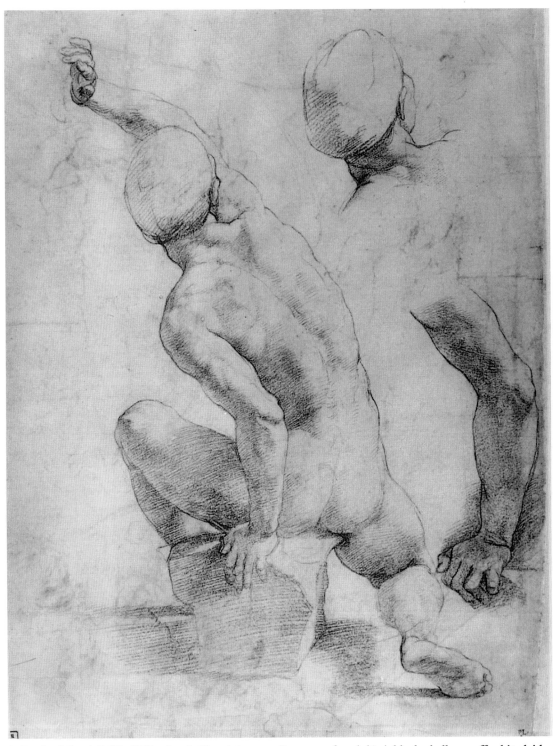

1. Raphael Santi (1483-1520), *A nude Man sitting on a Stone, seen from behind*; black chalk on off-white laid paper; 345 x 265 mm. Presented by a Body of Subscribers, 1846.200

# Techniques of Drawing

## from the 15th to 19th Centuries

with illustrations from the collection of drawings
in the Ashmolean Museum

# Ursula Weekes

Ashmolean Museum, Oxford
1999

*To Robin*

Cover illustration: Edouard Manet (1833–83), *Le déjeuner sur l'herbe*; pen and ink and watercolour on paper, 370 x 468 mm. Accepted by H.M. Government in lieu of inheritance tax on the estate of Dr and Mrs R. Walzer and allocated to the Ashmolean Museum, 1980.83

ISBN    1 85444 113 2

British Library Catalogue-in-Publication data:
A catalogue record of this book is available from the British Library

Designed and typeset in Bembo by Andrew Ivett
Printed and bound in Great Britain by Clifford Press Ltd, Coventry, 1999

# Contents

# ❧ *Introduction* ❧

*"Design, which by another name is called drawing…is the fount and body of painting and sculpture and architecture and of every other kind of painting and the root of all sciences."*

Michelangelo to Francisco de Hollanda[1]

Drawing has long been revered as the most basic skill of the artist and as the foundation of all other arts, for it is in the act of drawing that the artist's creativity finds its first expression. Although medieval manuscript illuminators were often fine draughtsmen, it was not until the 14th century that drawing was first valued as an independent pursuit. Medieval artists had worked out their initial compositional ideas on dispensable and temporary supports, such as scraps of parchment which were thrown away and tablets of boxwood or wax, which were used time and again by re-preparing the surface. However, as the manufacture of paper spread across Europe in the early 15th century (largely due to the demand from printers following the invention of moveable type *c.* 1440), not only did the practice of drawing become more widespread, but for the first time preparatory drawings were preserved as works of art in their own right.

This shift first occurred in Italy as a result of the importance attached to the concept of *disegno*, namely the creative idea made visible in the preliminary sketch and the recognition of drawing as a technique distinct from that of colouring. Leon Battista Alberti laid the foundations for this concept in his work *De Pictura*, 1435, by arguing that painting was a liberal art not a craft, and therefore deserved to be held in high esteem as a pursuit "worthy of free minds and noble intellects." Later in the 15th century, Leonardo da Vinci attached a divine mystique to the notion of *disegno*, believing that the creativity of the artist re-enacted God's creation of the world.

Among the drawings by Raphael in the Ashmolean is a double-sided sheet with studies for guards in a painting of the Resurrection (the project was never completed). The sheet can be seen as a paradigm for the stages of the creative process embodied in the Italian idea of *disegno*. What at first seems like a page of scribble on the verso (fig. 2), in fact provides a fascinating insight into the creative energy of the artist. Raphael's pen races with ideas which flow so quickly that he does not pause to use a new part of the page. He seems to turn figures round on their axis or adjust their centre of gravity, searching for the pose he required. Raphael left this sheet and returned to it at a later stage in order to make a careful figure study in black chalk on the recto (fig. 1). The pose of this nude seems to have evolved from a figure at the lower centre of

[1] Holroyd, C. *Michel Angelo Buonarotti. With Translations of the Life of the Master by His Scholar Ascanio Condivi, and Three Dialogues from the Portugese by Fancisco d'Ollanda,* 2nd ed, London, 1911, 275.

the verso, who is seen from behind with his right arm upraised and his head in two different positions. The black chalk study conforms to the ideals of outline, composition and the reflection of light, set out by Alberti in 1435. Moreover, the two sides of this sheet show the importance of different techniques for different sorts of drawings. Pen and ink was ideal for the rush of inventive thought, providing both the precision and fluidity needed for Raphael's flurry of ideas, while black chalk was far better suited to the more painterly study of light falling on the human figure.

Whereas Southern European artists explored compositional and poetic ideas in accordance with their concept of *disegno*, Northern European draughtsmen focused on the careful observation of nature. They were building on the celebrated tradition of 15th-century Flemish illuminators, such as the Master of Mary of Burgundy, who were renowned for their painting of illusionistic borders of flowers, insects and shells. However, Northern Renaissance draughtsmen were not only interested in the minutiae of plants and creatures, but also in the panorama of the landscape. The watercolour of an *Alpine Landscape* by Albrecht Dürer (fig. 28) is a stunning example of the way in which pure landscape was elevated to the rank of art in Northern Europe. The same scrutiny of nature is also found in early Netherlandish and German portrait drawings by artists such as Jan van Eyck, Rogier van der Weyden and Albrecht Dürer. Rogier van der Weyden's silverpoint drawing of the *Head of an Old Man* (fig. 4), probably a study for the head of Joseph in a paint-

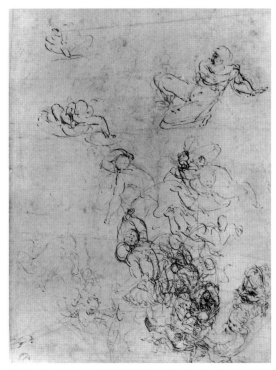

**2. Raphael Santi (1483–1520),** *Studies for the Resurrection*; **pen and brown ink; 345 x 265 mm. Presented by a Body of Subscribers, 1846.200**

ing of the Nativity now in Granada, records each line of the face and each hair of the beard with great precision.

Drawings were made for a multitude of purposes, which often affected the artist's choice of technique: cartoons were made to transfer designs onto the finished work of art; contract drawings were used to secure a commission; finished drawings were made as models for prints; preparatory studies were made for works in other media such as painting, sculpture and tapestry; drawings were made as academic exercises or as studies of landscape and nature. The differing functions of drawings had implications for the scale, colouring, level of finish and durability of the sheet, which meant that certain

7

media were more suitable than others for different tasks. However, the choice of technique was not merely determined by the function of the drawing. As the German artist Max Klinger (1857-1920) said, "every material is pervaded by a unique spirit and poetry, which in the hands of the artist greatly strengthens the character of the representation, and for which there is no substitute – in much the same way that the character of a piece of music depends upon its predetermined key." In other words, each drawing technique has specific characteristics, which fundamentally determine how the draughtsman interprets his subject. An artist who draws a landscape with a sharpened pencil needs to 'see' his subject in terms of lines, while the artist using brush and watercolour looks in terms of masses. It is for this reason that Walter Koschatzky argues that "to ask about the technique of drawing is to ask about the meaning of art [for] an artist's technique must comply with his internal vision."

While the Renaissance understanding of *disegno* still forms the basis of our definition of a drawing, developments such as that of watercolour painting and the proliferation of fabricated chalks and pastels during the 18th and 19th centuries have made a broader definition necessary. For the most part 'drawing', as a generic term, can be seen to cover any work of art executed by hand on paper, although to maintain this definition in the 20th century demands an increasingly broad interpretation of the distinction between a painting and a drawing.

This book traces the historical development of techniques of drawing in European art from the 15th to the 19th centuries, illustrated with examples from the collection of drawings at the Ashmolean Museum, Oxford. The collection began in 1846 when the University of Oxford acquired a remarkable group of drawings by Michelangelo and Raphael which had belonged to the portrait painter Sir Thomas Lawrence. By the early 1860s, the collection had been enriched with drawings from the collections of Chambers Hall, John Ruskin and Francis Douce, which included works by Leonardo da Vinci, Albrecht Dürer, Rembrandt van Rijn, Peter Paul Rubens, Claude Lorrain, J.M.W. Turner, Thomas Rowlandson, Hans Holbein and Antoine Watteau. From these impressive beginnings the collection has continued to grow by gift, bequest and purchase, acquiring drawings of an exceptional standard. The range and quality of the Ashmolean's collection makes it particularly suitable for an overview of drawing technique across more than five centuries.

# *Metalpoint*

The most common metal to be attached to the tip of a stylus and used for drawing was silver, although lead, copper and sometimes gold were also used. Silverpoint must be used on specially prepared paper, parchment or boxwood in order to make a mark. Preparations for paper (also called 'grounds') were made either from lead white, ground bone or ground egg shell. The powder was then mixed with glue water normally made from an animal glue such as rabbit skin. Once the preparation had been brushed onto the paper, it provided the necessary polished surface for the stylus to leave a thin deposit of silver. The deposit would quickly oxidise in the air and appear as a pale grey line. Drawings in silverpoint give the impression of great linear purity and preciseness because neither the width nor the tone value of the line would respond to changes in pressure. The application of greater force with the stylus would merely score the paper. Furthermore, silverpoint could not be erased, unlike lead point, which could be removed by rubbing breadcrumbs over the unwanted area. In order to achieve greater tonal variety, coloured pigments, such as the salmon pink in Fra Filippo Lippi's drawing *Study of Drapery* (fig. 3), could be added to the ground before painting it onto the drawing surface. The colour would act as the middle tone. Wash would be used to strengthen the deeper tones and white bodycolour to highlight the accents. Drawings using this technique are known as 'three-tone silverpoint drawings' and were characteristic of the 15th century.

Metalpoint was a medium well known to medieval craftsmen, who used it for the preliminary stages of manuscript illumination to outline details of miniatures, borders and historiated initials before painting. When drawing began to develop as an independent pursuit in the 14th century, silverpoint

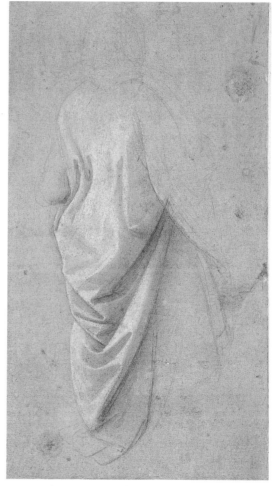

3. Fra Filippo Lippi (1406-1469), *Study of Drapery*; silverpoint, with brush and brown ink and heightened with bodycolour, on pink prepared paper; 175 x 99 mm. Bequeathed by Francis Douce, 1834.619

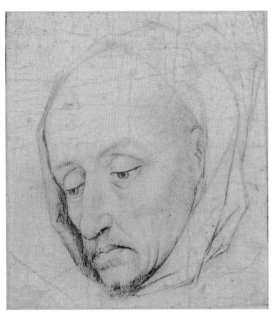

**4. Roger van der Weyden (1399-1464),** *Head of an Old Man*; **silverpoint on off-white prepared vellum; 84 x 76 mm. Purchased, 1935.96**

was the first medium with which an artist would learn to draw. Cennino Cennini, in his *Libro dell' Arte c.* 1390, considered silverpoint to be more valuable than any other drawing technique for training a young artist because of the control and discipline that it demanded of the draughtsman. During the 15th century, Italian artists such as Leonardo da Vinci, Pietro Perugino and Fra Filippo Lippi excelled in the use of silverpoint, as did Netherlandish artists of the same century, such as Jan van Eyck and Rogier van der Weyden (see fig. 4), who particularly favour-ed the technique for portrait drawings. However, silverpoint was noticeably less favoured by German draughtsman in prefer-ence to pen and ink.

Artists of the 16th century, seeking bolder and more illusionistic effects, increas-ingly neglected metalpoint as a medium in its own right, although one can often detect indications of lead point in drawings of the period. On rare occasions draughtsmen such as Hendrick Goltzius and Rembrandt van Rijn used silverpoint, which is evidence that the technique retained a certain mystique despite its general disuse.

From the late 17th to 19th centuries, the stylus was used merely as a tool in the preliminary stages of miniature painting. However, in the later decades of the 19th century, there was a modest revival of metalpoint drawing, especially in England among conservative artists such as Sir Muir-head Bone, William Strang and Alphonse Legros, who liked to use goldpoint as much as the more traditional silverpoint. The revival was perhaps influenced by the pub-lication of a number of late Medieval and Renaissance manuscripts on art techniques (for example Cennino Cennini's *Libro dell' Arte* was first published only in 1821 and the first English edition was prepared by Mrs Merrifield in 1844) and an awareness of the distinguished history of metalpoint drawing.

# Charcoal

Charcoal is made by heating twigs of an even-textured wood, such as willow, lime, beech or maple, in a chamber from which the supply of oxygen is excluded. This prevents the slender twigs from burning to ashes. The slower and more prolonged the heating, the softer and less brittle the end product. Charcoal may be recognised by its greyness in contrast to the more intense black produced by chalk. Its duller effect is especially noticeable in areas of broad tonal shading or stumping. Under magnification a charcoal line appears irregular and uneven because of the way particles tend to splinter from the stick. However, if artists wished to make the charcoal line indelible, they would soak the sticks in linseed oil overnight, a practice which was first documented in the 16th century, though never widely adopted. Manufacturers of charcoal in this century, while continuing to produce traditional charcoal, have also developed compressed charcoal, which provides a stroke of more concentrated blackness.

Charcoal is the most friable (meaning dry and easily crumbled) of all drawing media and can be erased easily using a feather or bread crumbs. From the earliest times, therefore, it was the most popular medium for drawing preliminary compositional outlines, later to be removed or painted over. Scientific analysis shows that charcoal underdrawing was used in prehistoric cave paintings at Altamira in Spain. Much later, the Greeks and Romans used it for sketching in large-scale mural compositions. Pliny the Elder mentions the use of

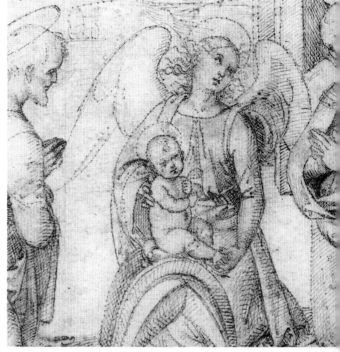

5. Formerly ascribed to Raphael Santi, *The Adoration of the Shepherds* (detail); pen and brown ink, pricked for transfer; 183 x 262 mm. Presented by Chambers Hall, 1855.90

charcoal and it has been found by archaeologists at Pompeii, near where he lived.

During the Middle Ages, the Renaissance and up to the 19th century, charcoal continued to be regarded predominantly as a preparatory drawing medium. Within the last twenty years the use of infra-red reflectograms has provided the necessary technology to see how important the use of charcoal was for underdrawing on early Netherlandish panel paintings. Since relatively few 15th-century Northern European drawings survive, and almost none in broad media such as charcoal or chalk, these underdrawings are important for our understanding of early

6. **Camille Corot (1796-1875),** *Landscape c.*1850-60; **charcoal and stump on buff paper; 357 x 473 mm. Beqeuathed by Mrs W.F.R. Weldon, 1937.19**

Northern Renaissance draughtsmanship.

Charcoal was widely used during the Italian Renaissance as the ideal medium for making cartoons for frescoes or large-scale oil paintings. Cartoons were generally pricked around the outlines and then charcoal dust could be 'pounced' through the holes to transfer the composition on to the final support, whether wet plaster, canvas or panel. The prick marks are clearly visible in the drawing once attributed to Raphael of *The Adoration of the Magi* (fig. 5), which is for the predella panel of an altarpiece. Despite extensive use during the 17th and 18th centuries, charcoal was not necessarily preferred as a drawing technique. However, as supplies of natural chalk ran dry in the 19th century, charcoal became the principal medium for figure studies and the standard tool for life drawings in the academies. By the mid-19th century charcoal had become an important independent medium, particularly in France, where it was used for finished exhibition drawings, especially of genre and landscape subjects. Camille Corot's drawing *Landscape c.*1850-60 (fig. 6) shows the wide range of effects that could be achieved by using different parts of the charcoal stick, such as a twist of the end stump, the long flat side or the sharp edge at the tip.

# Natural Chalks

The old natural chalks were mineral substances, which, after being mined from the earth and cut with a saw or knife into a suitable shape, needed no man-made processing. They were amorphous compositions in which the presence of a pigment, such as carbon (black), haematite (red), ochre (yellow), umber (brown) or calcite (white) was just as important as the presence of clay in the right proportion. This gave the chalk an even texture which was soft enough to draw with. If there was too much clay, the chalk would not be dry and powdery enough for drawing, but if there was too little clay, it would split and crumble when it was cut into a stick. The quality of the chalk also depended on the purity of this mixture. Gritty impurities would break up the flow of the draughtsman's strokes and leave unsightly scratches on the paper.

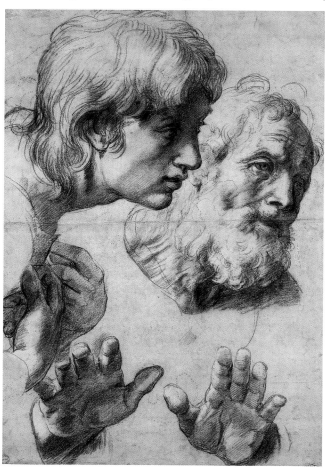

**7. Raphael Santi (1483-1520),** *Study of the Heads and Hands of two Apostles*; **black chalk touched with white chalk on off-white laid paper, pricked for transfer; 499 x 364 mm. Presented by a Body of Subscribers, 1846.209**

13

## Black Chalk

Natural black chalk (carbonaceous shale) is a mixture of carbon and clay, which was first mentioned by Cennino Cennini in the late 14th century. He recorded that deposits of the chalk could be found in Piedmont in Italy. Later writers, such as Vasari in the 16th century, Baldinucci in the 17th century and Langlois de Longueville in the early 19th century, referred to numerous places throughout Western Europe where black chalk lodes could be found, including France, Spain, Italy, Germany, Wales and the Hebrides.

Towards the end of the 15th century and throughout the 16th century, black chalk became one of the most favoured of all drawing media in the artist's workshop. As a broad medium, chalk demanded work on a relatively large scale compared to metalpoint, which meant that its use was hindered during the 15th century while paper was less freely available and more expensive. Consequently, chalk drawings dating from before about 1490 are extremely rare. However, there were also purely artistic reasons for the popularity of black chalk in the early 16th century. As paintings began to be made on a larger scale than before, in part as a result of the increasing preference for painting in oil rather than egg tempera, so artists sought drawing techniques which had more inherently painterly characteristics. Black chalk was ideal in this respect not only because of its freedom of handling, but also because of its wide range of tone from light to dark, enabling the artist to

8. Matthias Grünewald (1475/80–1528), *Elderly Woman with her Hands clasped*; black chalk on off-white laid paper; 377 x 236 mm. Bequeathed by Francis Douce, 1834.421

portray the precise fall of light on a three-dimensional surface such as the human figure. By the 16th century, draughtsmen searching for bolder methods of rendering the spontaneity of movement and the plasticity of form found black chalk the most suitable medium to fulfil their artistic objectives. Few sheets better illustrate these developments than the marvellous auxiliary cartoon *Heads and Hands of two Apostles* by Raphael (fig. 7), a study for his painting of *The Transfiguration* in the Vatican. Black chalk was often used for

cartoons, as well as for underdrawing in paintings (although it could not be as easily removed as charcoal), preparatory studies and finished drawings in their own right.

Until the 17th century the use of chalk was generally preferred more by Southern European draughtsmen than by their Northern counterparts. For this reason the black chalk drawing by Matthius Grünewald of *An elderly Woman with her Hands clasped* (fig. 8) is especially noteworthy, not only as a work of great intrinsic beauty, but also as a rare example of an early Northern European chalk drawing of the finest quality. During the 18th century, black chalk heightened with white chalk was often used for drawing the human figure in the French academies, once the art of drawing in red chalk had first been mastered in preliminary classes. However, towards the end of the 18th century the popularity of natural black chalk declined as supplies of an adequate quality became scarce and the development of fine fabricated chalks and graphite pencils with added lampblack provided an alternative.

## Red Chalk

Natural red chalk is haematite (iron oxide) suspended in clay. It was harder than natural black chalk and thus its linear clarity could be used to advantage for more detailed and finely worked studies on a smaller scale. While the chromatic vibrancy of red chalk is obvious, its tonal range is less varied than black chalk, with no deep darks. However, by licking or wetting the chalk, a cooler, darker colour and a more solid line could be achieved, and by rubbing the chalk with a finger or stump a warmer orange-red appearance could be created. These effects are due to the flat disk-shape of the haematite particles in natural red chalk. Normally the particles lie randomly arranged and thus they scatter the light, giving the characteristic vitality of colour. Rubbing the chalk decreases the density of the particles, consequently giving more space for light to be refracted by the pigment and reflected by the paper. In contrast, by wetting the chalk, the disk-shaped particles are smoothed down and lie flat on the paper and thus appear as a darker colour. Fabricated red chalk is much less versatile than the natural variety because, although not chemically different, its particles are spherical and consequently refract the light in a uniform manner.

Vasari stated in 1555 that red chalk came from Germany, although later sources also mentioned deposits in Italy, Spain, Flanders and France. It is interesting, given Vasari's statement, that red chalk was so little used by German artists. Leonardo da Vinci was the first to master the qualities of red chalk, which perhaps became the technique most closely identified with the great achievements of the Italian Renaissance. Thereafter it was particularly favoured in Florence and Parma, where artists recognised and exploited the excellent physical properties of red chalk, especially for conveying the soft flesh tones of the nude figure. Michelangelo's use of red chalk for his 'presentation drawings' in the period around the 1520s, such as the *Ideal Head c.*1518-20 (fig. 9), reached unsurpassed mastery of the

9. Michelangelo Buonarotti (1475–1564), *Ideal Head*; red chalk on off-white laid paper; 205 x 165 mm. Presented by a Body of Subscribers, 1846.61

10. Peter Paul Rubens (1577–1640), *A female Nude reclining*; red chalk, heightened with white chalk on buff paper; 250 x 178 mm. Purchased, 1954.146

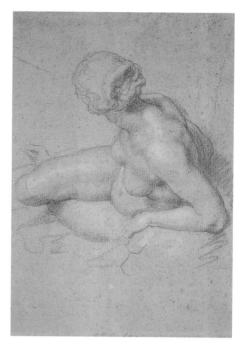

11. Bernard Picart (1673–1733), *Academic Study of a Nude Male Figure lying on Rock*; red chalk on off-white laid paper; 382 x 484 mm. Presented by Mrs J.A.R. Monro, 1944.14

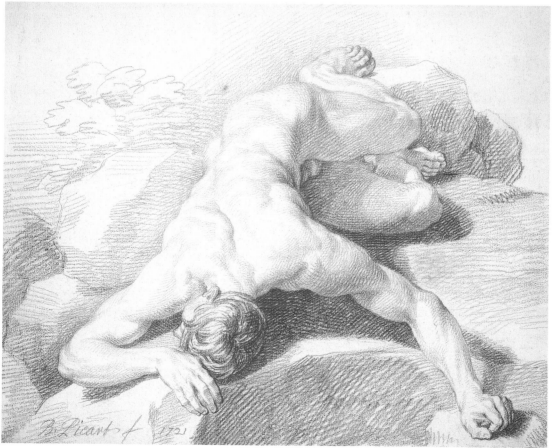

17

technique. He loved to play off the contrasts of fine detail and suggestive outlines, of movement and stillness and of light and shade against one another. Michelangelo was known never to sell his presentation drawings, but gave them instead to members of his close circle of friends as precious gifts.

Red chalk remained a revered medium among 17th-century artists, such as Peter Paul Rubens, who wished to be associated with the aspirations of the Renaissance (see fig. 10). By the 18th century, red chalk had become the stipulated medium for pupils beginning their training in life drawing at the French Academy of Painting and Sculpture, founded in the mid-17th century to promote painting as a liberal art. Bernard Picart's *Study of a Nude Male Figure lying on Rock* (fig. 11) is a classic example of an 18th-century academic life-study. Many French artists could have echoed the statement made by J.A.D. Ingres, "I was raised on red chalk". In 1681 Filippo Baldinucci commented that red chalk was the colour of blood and it has often been known by the French term 'sanguine' (meaning blood) from the late 17th century onwards.

Red chalk was also important for printmaking processes from the 16th to 18th centuries, being used to transfer images in two different ways. The first and earlier method was that of smearing the back of the drawing with red chalk and then tracing over the outlines with a stylus onto a dampened sheet below. The second method was that of counterproofing, which yielded a reversed image of the drawing, so that the printmaker could see what his design would look like in its printed state. To obtain a counterproof, the drawing would be run through a roller press together with a second sheet of paper placed on top. By slightly dampening both sheets all the excess loose chalk would be transferred to the blank sheet while under pressure. In 1775, Charles-Antoine Jombert also recommended artists to use counterproofing as a means to fix their sanguine drawings. In addition, documentary evidence from the mid-17th century shows that when sales of drawings were being negotiated, counterproofs rather than the originals were often sent for inspection.

Towards the end of the 18th century, natural red chalk had been mined so heavily that what remained was generally hard and gritty and much darker in colour. Artificial red chalk was made as early as 1760 to try and cope with the demand, but it was not until the 19th century that satisfactory alternatives to the natural product were readily available (see the section on fabricated chalks and pastels).

## Other Coloured Chalks

The draughtsman was able to increase the breadth of tonal range by using more than one chalk. In particular, natural white chalk (calcite or, less commonly, soapstone) was used to heighten areas caught by the light. Calcite is the most dry and crumbly of all natural chalks and its fluffy texture gives it a brilliant white appearance. Unlike black and red chalk, natural resources of white chalk are still plentiful; for instance the cliffs around Dover and in Brittany are made of calcite. There are some examples of drawings in other natural coloured chalks, such as brown

(umber) and yellow (ochre). The use of such chalks ranged in date from the 16th to 18th centuries. However, drawings in this medium tend to occupy an exceptional position even in the oeuvre of artists who liked to draw with these materials.

Although artists have always been known to use combinations of two chalks, it was in the 18th century that the most innovative developments in a mixed chalk technique took place. In about 1712, Antoine Watteau began to experiment with the juxtaposition of black, red and white chalk, perhaps inspired by drawings in three chalks by Rubens, which he could have seen in collections in Paris. His technique became known as the *trois crayons* method, in which each colour retained its independence within the composition. It reached a high point in Watteau's work between 1715 and 1717, which is the period from which his drawing of a *Girl with a Music Book* (fig. 13) dates.

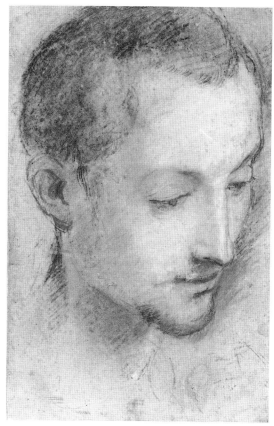

12. Federico Barocci (1535–1612), *Head of a Young Man*; black chalk, with pink, white and red fabricated chalk on greyish paper; 330 x 218 mm. Purchased, 1948.83

## Fixatives

Many old master drawings would not have been fixed at all. Their preservation to this day shows not only how durable they are, but also how carefully they were preserved in the artist's workshop and subsequently by generations of collectors. However, fixatives were first known and used in the 15th century. Drawings could be immersed in a gum bath (water with a small amount of gum arabic) and then dried. Alternatively, the support could be prepared with gum and then steamed after the drawing was complete in order to make the chalk adhere to the gum preparation. This technique was mentioned by Giovanni Battista Volpato and Samuel van Hoogstraeten, who were both 17th-century painters and writers on art. Other sources suggested that drawings should be quickly brushed over with a large brush dipped in egg white.

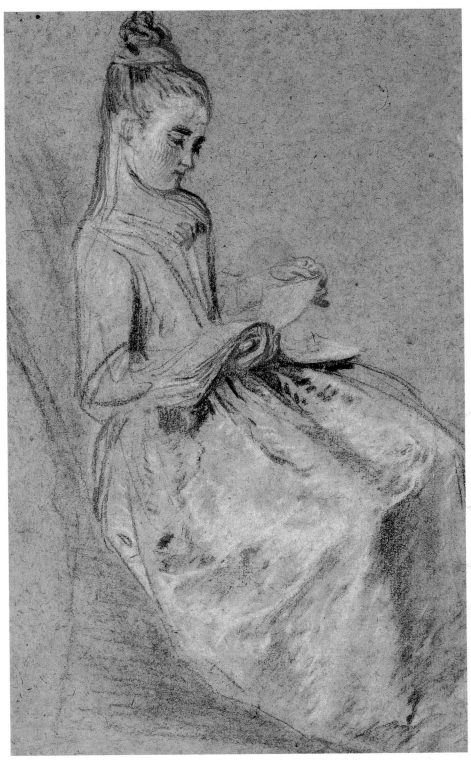

13. Antoine Watteau (1684–1721), *Girl with a Music Book*; black, white and red chalk on buff paper; 246 x 156 mm. Presented by Mrs Emma Joseph, 1942.46

 # *Fabricated Chalks and Pastels*

Fabricated chalks or pastels are made by mixing dry pigments with a binder to make a paste, which is then rolled into a stick and dried. Not only did this method mean more basic colours were available than occur naturally as chalk, but by mixing two or more pigments, and by using white to vary chromatic strength, any number of colours could be created. Technically, there is no difference between fabricated chalk and pastel, but the term 'pastel' became so closely associated with the soft effects produced in broad, colouristic drawings of the 18th and 19th centuries, that it is necessary to retain a distinction between softer pastels and drier, friable (crumbly) fabricated chalks. Today, the term 'pastel' often refers to oil pastels, which are different in their composition, using linseed oil or olive oil as a binder. This gives oil pastels a particular sheen and greater fluidity of handling.

It is thought that Leonardo da Vinci was the first to have made written reference to fabricated chalk/pastel. He called it "the manner of dry colouring" and reported that he learnt it from a French artist called Jean Perréal, who came to Milan with Louis XII in 1499. Later in the same year Leonardo made his famous portrait drawing of *Isabella d'Este* (now in the Louvre, Paris), in which he used yellow, brown and pink pastels. During the 16th century, pastel was primarily used to add a light toning of colour to portrait drawings, such as the group of drawings by Hans Holbein of the court of Henry VIII, now in the Royal Collection. Federico

Barocci, born in Urbino in 1526, often used pastels in his studies of heads and faces, such as in *Head of a Young Man* (fig. 12). Towards the end of the 16th century, the process for making pastel was described in two texts. The first, published in Cologne in 1583, was by Petrus Gregorius, "painters fashion crayons in cylindrical form and roll them with a mixture of fish glue, gum arabic, fig juice, or what is to my mind better, whey." A year later in 1584, the Italian Giovanni Paolo Lomazzo referred to a method of drawing "a pastello" in his *Trattato dell'arte della pittura*.

**14. Edmund Ashfield (*fl. 1660–1690*), *Portrait of an Unknown Man*; coloured chalks with some bodycolour on buff paper; 268 x 218 mm. Purchased, 1955.34**

21

Old recipes for making fabricated chalks, ranging from the 16th to 19th centuries, suggested a wide variety of binding media. In addition to those mentioned by Gregorius, there was plant gum (tragacanth), plaster of Paris, milk, beer and honey. The different binding strengths of these substances indicate how varied the texture of fabricated chalks and pastels could be. The recipes favoured by earlier artists suggest that they inclined towards making harder rather than softer chalks, perhaps because they could copy the qualities of natural chalk more closely.

From the second half of the 17th century, artists began to use softer chalks in order to create 'pastel paintings', in which colours blended into one another by extensive use of stump (a coil of paper or leather with a blunt end used for rubbing the drawing). It was an art of surface effects, which consciously sought to emulate the qualities of oil paintings. Pastel was favoured not only for the rich velvety texture of its finish and its air of spontaneity, but also because, by using stump, it was easy for the artist to re-work unsuccessful areas. Pastel portraits were immensely popular during the 18th century, especially in France, where artists such as Jean-Siméon Chardin, François Boucher and Maurice-Quentin de la Tour excelled at the art. The admission of Joseph Vivien to the French Academy as a 'pastel painter' as early as 1701 shows the high status enjoyed by the art of pastel painting in this period.

The impetus to improve the manufacture of fabricated chalks came in the late 18th century as supplies of natural chalk began to run dry. As early as 1760 fabricated red chalk was being made in France. By 1799 A.F. Lomet commented in *Annales de Chimie* that the best chalks were now of the fabricated variety because the only natural red chalk still available was hard, gritty and uneven in consistency. The commercial production of fabricated black chalk developed in the last decade of the 18th century just as red chalk was beginning to fall out of fashion. In 1795 the Conté Company patented their procedure for making black chalk in varying degrees of hardness (the patent also applied to the production of graphite pencils). Fabricated black chalks tended to have a more intense black line than natural black chalk. 'Conté-crayons,' as these chalks were known, were cased like pencils, as Vincent van Gogh noted in a letter to his brother in September 1881, "I brought along some conté-crayon in wood (just like pencils) from The Hague and I work with them a great deal now." Fabricated black chalk was also used by artists as a means of emulating the soft, atmospheric tone of certain print-making processes such as stipple engraving and mezzotint, which were in their heyday during the 18th and early 19th centuries. The drawing *Love preferring Innocence to Riches*, by Pierre-Paul Prud'hon (fig. 16), was made as the model for a stipple engraving,

After a decline in the use of softer chalks in the early 19th century, pastels became extremely popular among French Impressionist and English Pre-Raphaelite artists from the mid-19th century onwards. The Impressionists found pastel ideal for capturing the fleeting effects of light and colour in the world around them. Pastel blurred the distinction between line and colour

**15. Hilaire-Germain-Edgar Degas (1834-1917),** *Three Studies of a Ballet Dancer*; charcoal and pastel on sand coloured paper; 390 x 638 mm. Bequeathed by Mrs W.F.R. Weldon, 1937.23

and was thus invaluable for artists such as Claude Monet, Auguste Renoir, Henri de Toulouse-Lautrec and above all Edgar Degas, who sought to record momentary sensations and to convey the speed and spontaneity of Parisian life. Increasingly Degas, and other artists following his example, made no attempt to blend in strokes and instead allowed bright colours to co-exist side by side, leaving them to harmonise in the eye of the viewer when seen from a distance. This is the technique also used by the Russian artist, Leonid Pasternak, in the portrait of his sons *Boris and Alexander Pasternak*

(fig. 18). In contrast, the Pre-Raphaelites found the medium well suited to the romantic and pensive nature of their artistic vision. Rossetti's *Study for the Head of an Attendant Spirit* (fig. 17) is masterly in its blending of innumerable tones of browns and pinks. Towards the end of the 19th century, and into the 20th century, Symbolist artists, notably Odilon Redon, found they were drawn to the versatile qualities of pastel. No longer was the technique used as a means of evoking reality, but rather as a vehicle for expressing the inner world of dreams, imagination and the unconscious.

16. **Pierre-Paul Prud'hon** (1758–1823), *Innocence preferring Love to Riches*; black and white chalk with stumping and stippling on blue paper; 454 x 345 mm. Purchased, 1952.105

**17. Dante Gabriel Rossetti (1828–1882),** *Head of a Woman, Study for the Attendant Spirit in 'Astarte Syriaca'*; coloured chalks on pale green paper; 500 x 355 mm. Bequeathed by John Bryson, 1977.84

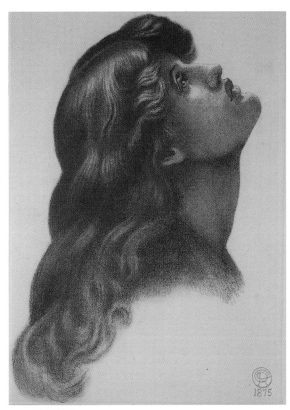

**18. Leonid Pasternak (1862–1945),** *Portraits of Boris and Alexander Pasternak*; pastel; 428 x 635 mm. Presented by Mrs Pasternak and Mrs Pasternak-Slater, 1963.30

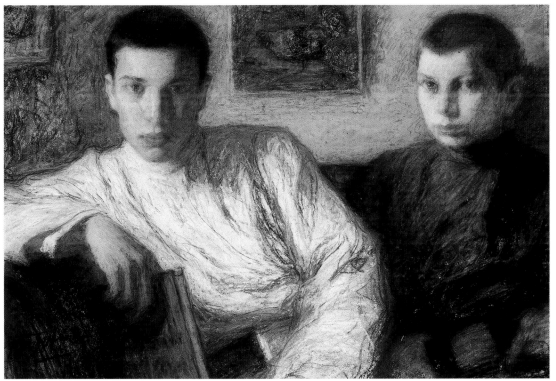

# Crayon

Over several centuries, the term 'crayon' has been somewhat ambiguously used to refer to a variety of drawing instruments. In the strict sense, a crayon differs from a fabricated chalk and pastel in that it is made with a waxy or greasy binding medium such as spermaceti (white wax from a sperm whale) or soap. These fatty binders envelop the colour particles, providing a rich colour and sleek appearance to the strokes. Crayons suited artists whose draughtsmanship was linear, since they tended to resist smudging and were not as crumbly as other chalks, thereby limiting their usefulness for broad tonal shading on a large scale.

Historically, the preparation of crayons seems to have occurred in a sporadic manner. Although Leonardo da Vinci describes using wax to "make good crayons", it was not until 1797 that a specific recipe for making crayons was first published, in Hochheimer's *Chemische Farben-Lehre*. In 1798 crayons became indispensable for a new printing process called lithography, which was invented by Alois Senefelder in Munich. Lithography is based on the principle that water and grease repel each other. The artist would draw in wax crayon on a tablet of limestone, which would then be dampened with water so that only the blank areas became wet. When greasy printing ink was applied, it would be repelled from the blank areas by the water and would adhere only to the wax crayon drawing. A sheet of paper

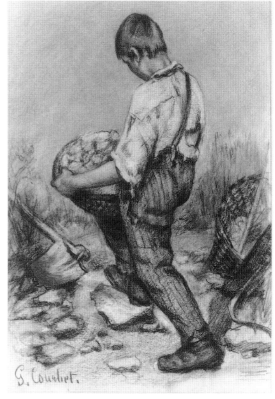

**19. Gustave Courbet (1819–1877), *Young Stone Breaker*; black crayon and white chalk, with stumping on cream paper; 294 x 211. Purchased, 1998.3**

would then be laid on the limestone and placed in a press in order to obtain the lithograph. The drawing in black crayon of a *Young Stonebreaker* by Gustave Courbet (fig. 19), whose surviving works on paper are rare, was made into a lithograph and published in 1865 as a gillotage (a print from a lithograph, made by a photomechanical process, so that text could be incorporated with the image).

# *Graphite Pencil*

'Pencil' was the name originally used for a small brush. However, during the 17th century the term began to be used for a thin strip of graphite encased in wood. For instance, in 1683, Sir John Pettus, Deputy Governor of the Royal Mines in England, referred to the instrument as a 'dry pencil'.

Graphite is a crystalline form of carbon, which can be distinguished from black chalk by its delicate metallic sheen. It was first excavated in Bavaria in the early 13th century, but it was not until pure graphite was discovered in 1504 in England, at Borrowdale in Cumbria, that graphite was fully exploited as a medium for drawing. By the 1580s there was a mine in operation at Borrowdale, although graphite only began to be mined there on a large scale in the 1660s. This deposit was the only known source of pure graphite, so pencils were for a short time known as 'crayons d'Angleterre'. The mineral was highly prized and subject to severe export restrictions.

During the second half of the 16th century, graphite was sometimes used for underdrawing, in the place of lead point. This may be the source of the misleading term 'lead pencil', even though a pencil contains no lead. A reference to the carpenter Friedrich Staedtler as 'pencil maker' in 1662 shows that pencils were being made in Germany by the mid-17th century. In 1760 the Faber pencil factory was established in Nuremberg, although in the absence of pure graphite, they made their not altogether successful 'leads' from pulverised graphite bound by means of gums, resins and glues.

The most significant development in the production of pencils occurred during the Revolutionary and Napoleonic wars, when trade in graphite from England to France was halted. Nicolas-Jacques Conté (1755-1805) invented, and in 1795 patented, a process for making graphite pencils of varying degrees of hardness by mixing milled graphite with varying proportions of china clay and then firing it in a kiln. Harder pencils were lighter in colour, having a greater proportion of china clay than the

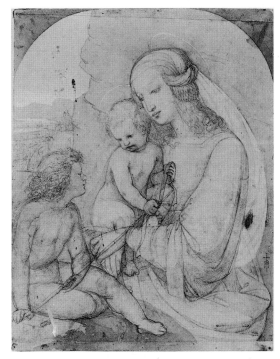

**20. Heinrich Schwemminger (1803-1884),** *Madonna and Child with the Infant St John*; **graphite with pale brown wash and bodycolour on card faced with paper, some grey wash on the card backing along upper edge; 191 x 150 mm. Purchased, 1996.18**

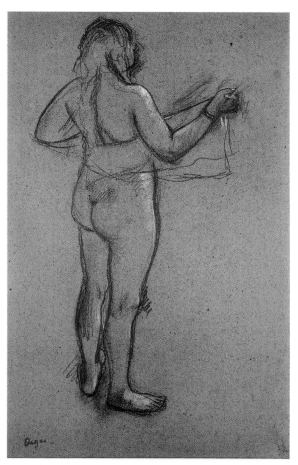

**21. Hilaire-Germain-Edgar Degas (1834-1917),** *Nude Woman drying herself*; **graphite and white chalk on grey-green paper; 432 x 279. Purchased, 1942.102**

softer, blacker degrees. Pencils today are classified with the letter *H* for 'Hard' or *B* for 'Black' and are graded further by numerical division.

As a result of Conté's innovation, the use of pencil became widespread in the 19th century. The harder grades of pencil became the principal successors to the metalpoints, and as such, they were much favoured by the school of 19th-century German artists called the Nazarenes. Their linear draughtsmanship reflected the profound influence of late Gothic and early Renaissance drawing techniques. By the use of wash and body-colour, they consciously emulated the 'three-tone' silverpoint drawings of the 15th century, such as Heinrich Schwemminger's *Madonna and Child with the Infant St John* (fig. 20). One of the finest draughtsmen to have exploited the different characteristics of pencil was the French artist Edgar Degas, who demonstrated the metallic lustre of graphite in the broad, crumbling strokes of his life drawings, such as *A Woman drying herself* (fig. 21). Synthetic graphite has been produced commercially since 1897.

# Pen & Ink

Among the different techniques of drawing, there can be none more consistently employed over the past six centuries than pen and ink. Many artists appear to have found it the natural medium for the dynamic, conceptual stages of composition and for resolving artistic problems, while others used pen and ink to create spectacular independent works of art.

Up to the end of the 19th century, there were three basic types of pen – reed, quill and metal; and four main types of ink – carbon, iron-gall, bistre and sepia.

## Reed Pen

The oldest pens, used as writing instruments by the Egyptians and later by the Romans, were made from dried reeds. A nib could easily be cut into bamboo or the type of coarse, hollow-barrelled reeds which grow beside streams in Europe. Reed pens tend to require a relatively broad nib which sheds its ink more quickly than quills, producing short interrupted lines. During the Middle Ages, therefore, scribes found them unwieldy for fine manuscripts and they were used only for very large writing, in choir books for example. For the same reasons few old master draughtsmen chose to use reed pens. However, a notable exception was Rembrandt van Rijn (1606-1669), for whom the vigorous, angular strokes of the pen held great appeal, as a means to heighten the dramatic tension of his narrative subjects, such as *Jael and Sisera* (fig. 22). It was

not until the mid-19th century that Edouard Manet again began to make a virtue of the neglected reed pen, followed later in the century by Vincent van Gogh and Henri Matisse.

## Quill Pen

Quill pens were made by cutting and paring down the end of a bird's wing or tail feather into a nib. The earliest reference to quill pens was made in the 7th century by St Isidore of Seville. However, it was not until Theophilus (Roger of Helmarshausen) wrote *De Diversis Artibus* in the 12th century that any writer recommended a particular type of feather above another, suggesting that goose feathers were the most suitable for writing and drawing. Artists' manuals of later centuries also commended swan quills and, for very fine and delicate work, pens cut from the quills of ravens and crows.

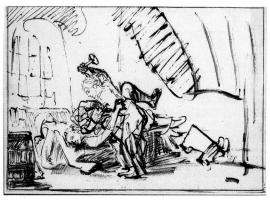

22. **Rembrandt van Rijn (1606–1669),** *Jael and Sisera*; **reed pen and brown ink on off-white laid paper; 174 x 255 mm. Purchased, 1950.51**

Draughtsmen favoured quills because they could be cut to a sharper point than reed pens and because they could hold a greater reservoir of ink. This would be released through the slit of the nib at an even pace, producing long, graceful strokes. The organic composition of the quill was uniquely suited to respond to slight changes of pressure and speed in the artist's hand, creating swelling or tapering lines as well as subtle variation in the tonal strength of the ink. Michaelangelo's *Dragon* (fig. 23) and Hendrick Goltzius's *Head of Mercury* (fig. 24), both drawn with the quill, are pieces of pure virtuosity in this respect.

Cennino Cennini advised that only after the apprentice had learned the discipline of silverpoint drawing (a period of at least a year) should he attempt to draw in pen and ink. He believed that the flexibility and freedom of the quill encouraged the development of a personal graphic style at too early a stage. It was 15th- and 16th-century artists of the German School who most exclusively favoured the quill as a drawing technique. However, quill pens remained in constant use across Europe from the 15th century to the 19th century. Most old masters would have cut their own quills. However, quills were also sold on market stalls, and by the 18th century, in stationery shops. The Dutch were the first to try and make quills more hard-wearing by sinking the barrel of the feather in hot ashes or heated sand in order to extract natural moisture and grease. Hence, quills were sometimes known as 'Dutch pens.'

## Metal Pen

Metal pens were known from the time of the Romans, and during the 15th and 16th centuries gold or silver pens were given as expensive presents. However, metal pens only became widespread after about 1831, the year in which Joseph Gillot of Birmingham patented his design for the first successful steel nib. It was both flexible and resistant to the corrosive components of common ink. Increasingly quills were neglected as the durability and consistency of the metal pen was preferred, not least because the crisp, uncompromising line of the steel pen reproduced well in cheap books, magazines and newspapers. Until the late 19th century, metal pens were dipped into an ink bottle immediately before drawing. Fountain pens, in which the ink is drawn up by suction through the nib and held in a reservoir, were known in the 17th century, although they only became practical as writing or drawing instruments as a result of the improvements made by L.E. Waterman in the 1880s.

## Carbon Ink

The earliest inks, made by the ancient Egyptians and Chinese were carbon-based, producing dark black inks. Carbon particles, from the soot of burning oils or resins (lampblack), from roasting wine sediment (yeast black), from burnt bones (ivory black) or from the charcoal of wood, were ground to a powder and combined with a binding medium. The ancient Chinese used animal or fish glue as a binder and took great care over the process of mixing the carbon and

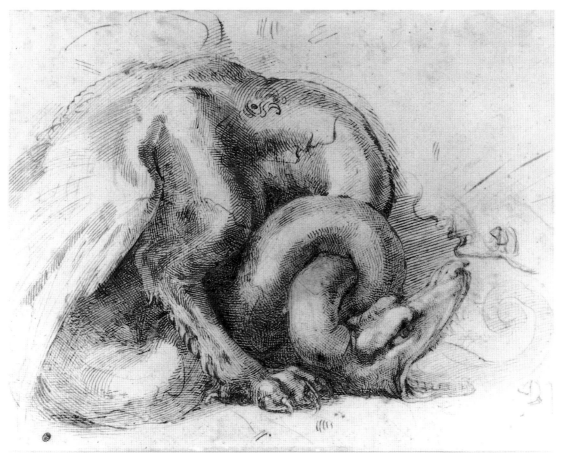

**23. Michelangelo Buonarotti (1475–1564),** *A Dragon and other Sketches*; **pen and brown ink over black chalk outlines; 254 x 338 mm. Presented by a Body of Subscribers, 1846.69**

glue to make a paste, which would then be pressed and dried into sticks or cakes. When the ink was needed, the end of the stick would be wetted to yield as much liquid as was required at the time. The carbon inks prepared in Egypt and later in India and Europe used binding media such as plant gums and gum arabic (from the acacia tree). Carbon inks are chemically stable and do not change in colour through the passage of time. This was especially true of Chinese ink, which on account of the strength of the binder and the fine dispersal of carbon pigment, penetrated the paper support more deeply than gum-based carbon inks.

Recipes for making carbon inks were published in Europe from the 12th century onwards. A German book printed in 1531 directed the reader to "take a wax candle, light it and hold it under a clean basin until the soot hangs to it; then pour a little warm gum water into it and temper the two together –and then that's an ink." Carbon ink tended to be used more for drawing than for writing, since it was more expensive to produce than common iron gall ink.

31

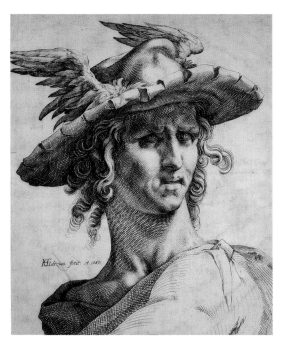

24. Hendrick Goltzius (1558-1617), *Head of Mercury*; quill pen and carbon ink on off-white laid paper; 444 x 365 mm. Purchased, 1954.1

25. Giambattista Tiepolo (1696–1770), *The Virgin and Child with the Infant St John*; pen and iron gall ink with wash over black chalk on off-white laid paper; 190 x 161 mm. Bequeathed by F.F. Madan, 1962.17.56

## Iron Gall Ink

Iron gall ink was the most commonly used ink for everyday writing and for legal documents, as well as often being used for drawing. Unlike other inks, its colour and strength was produced by a chemical reaction between tannic acid, extracted from ground gall-nuts or oak apples (an abnormal growth on certain trees, especially oak) and a solution of iron (ferrous) sulphate, after which gum arabic was added as a binder. This chemical reaction is unstable, which meant that the ink would go through several phases. When 'fresh', iron gall ink appeared a pale violet-grey colour, but the pen lines turned black in the air within a matter of hours. After a number of years, the colour of the ink would change from black to brown. In some cases, extreme acidity in iron gall ink, and possibly the formation of iron oxide, caused a corrosive action which ate through the paper's fibres in the areas where most ink was deposited. Michelangelo, Guercino, Giambattista Tiepolo and van Dyck are among those artists whose inks have 'burned' the paper in this way over the years (see fig. 25).

## Bistre

Bistre was made from the soluble tars and fine carbon particles in wood soot, which would accumulate on the chimney close to the heart of the fire. After the soot had been ground down, perhaps with a small amount of wine, it would be dissolved in water

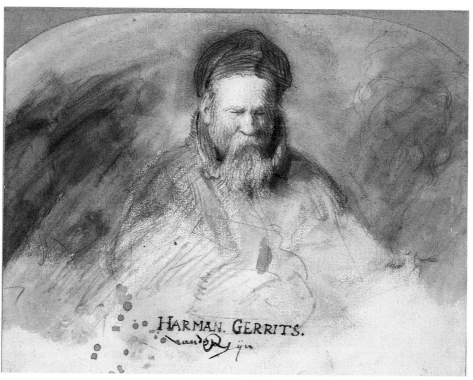

26. Rembrandt van Rijn (1606–1669), *Portrait of an Old Man*; red and black chalk with pen and ink and washed with bistre; 189 x 240 mm. Presented by Chambers Hall, 1855.11

27. Frederick Mackenzie, *View of the New Front at Pembroke College*; pen and brush in sepia and dark brown ink on white wove paper; 219 x 314 mm. Deposited by the Delegates of the Clarendon Press, 1850.86

before being strained to remove any coarse residue. The addition of a binder such as gum arabic was not normally necessary since the ink contained sufficient natural binding properties. Bistre was valued for its warm colour, ranging in tone from yellowish-brown to dark brown. The colour of the ink depended on the wood from which it was derived – beech was often cited in manuals as one of the best woods to use. The vibrant colour of the ink comes across clearly in the poignant drawing of the artist's father *Harmen Gerritz* by Rembrandt van Rijn (fig. 26). Although bistre could achieve striking contrasts on account of its rich colour, its value range was limited. Even at its most concentrated the ink could not approach black notes and therefore it was always regarded primarily as a drawing rather than writing ink. If the artist used bistre on paper which was not well sized (in other words very absorbent paper) then the soluble tars would soak into the paper, leaving only the fine carbon particles on the surface. As a result the ink would appear a dull brownish-grey. The earliest mention of the raw material for bistre was made by Jehan Le Begue in 1431, but it was spoken of in connection with drawing only in later centuries: Lomazzo in 1584, Baldinucci in 1681 and van Hoogstraeten in 1678. It appears that Sir Théodore Turquet de Mayerne first named the ink in print by its French term 'bistre'. Certainly by the 18th century this name had become common currency.

## Sepia

The term 'sepia' has often been misused to describe all brown inks. However, genuine sepia was a medium hardly used before the 19th century, as is indicated by the fact that it was never referred to in earlier artists' manuals. Sepia ink is the dark brown liquid in the ink sacs of cuttlefish (and squid) with which they cloud the surrounding water in order to provide self-protection. In 1830 Langlois de Longueville gave extensive instructions on how to prepare sepia: "Many [cuttlefish] are found in the Mediterranean, the Adriatic Sea, the Atlantic Ocean and the English Channel. The bladder of this fish, filled with liquid, is dried in the sun … one begins by pounding a large number of these bladders and putting the dry colour which they contain into a glazed vessel full of pure, boiling water … the water is decanted four times and the sediments which are floated off serve to make cakes of high quality". The cakes were then mixed in a solution of gum arabic and used for drawing. Drawings in sepia can be difficult to identify, not only because it is similar in colour to other brown inks, but also because it was often mixed with other pigments to make coloured washes. It tended to be more closely associated as a material for wash and watercolour drawing than as an ink for pen work, as the translucency of Frederick Mackenzie's *The New Front of Pembroke College* illustrates (fig. 27).

Watercolour is made from dry pigments suspended in water with gum arabic as a binder (in this sense some inks are also watercolours). The pigment needs to be ground into minute particles if it is to remain suspended indefinitely in the water rather than settling at the bottom. The gum arabic ensures the even dispersal of the particles throughout the solution and acts as a glue, fixing each speck of pigment to the paper as it dries. Watercolour is transparent and thus the paper plays a vital role in creating the luminous effect of colour. Light is reflected not simply off the pigment itself, but off the white paper and *through* the pigment laid on top, back to the eye. Hence, variety of tone and colour is most successfully achieved by applying thin layers of wash over one another rather than using saturated colour. The impurities in most pigments and their differing natural binding properties meant skill and experience was required to make successful watercolour paints. For this reason the invention of dry-cake colours, by the English colourman William Reeves *c.* 1780, was hailed as a radical innovation. For the first time artists could buy ready-made watercolours, which required nothing more than some of the dry cake mixing with water. During the early 19th century, French colour manufacturers experimented with honey in order to make moist colours (paste-like in their consistency) which were kept in tubes like oil paints. Moist colours were introduced in England by Winsor & Newton in 1846.

Unlike traditional oil-painting brushes, which have stiff hairs of equal length, watercolour brushes require a large body of hairs (to provide a reservoir for the fluid), but a tapering point so that surface tension will keep it from discharging through the small outlet all at once. Traditionally, the best watercolour brushes were made of the hair of the Russian sable, set in a bird's quill. An advertisement from Winsor & Newton in 1854 graded their finest sable brushes in size, from a crow quill as the smallest up to a large swan quill. They also offered even larger brushes "for skies, washes and large works", which were set in metal ferrules with black polished handles. Such brushes were necessary to lay an even wash.

Watercolour was used on Egyptian papyrus rolls and can also be found in many medieval European manuscripts. During the 15th century, watercolour was widely used for colouring early woodcuts, although the manner of colouring tended to be crude. Albrecht Dürer was the first artist fully to exploit watercolour as an independent drawing medium, particularly for studies of landscape and nature. The drawing of an *Alpine Landscape,* 1494, (fig. 28) was drawn by Dürer as he crossed the Alps on his first journey to Italy. It depicts a scene in the Val di Cembra, north east of Trento. The drawings Dürer made on this journey are the first watercolours of pure landscape and thus it may justifiably be argued that the celebrated tradition of 18th- and 19th-century landscape watercolour finds its origin in these sheets.

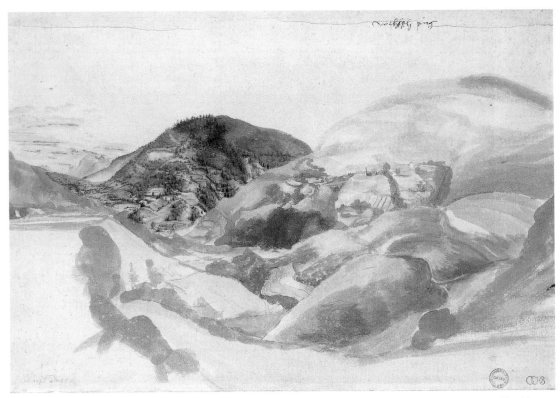

28. Albrecht Dürer (1471-1528), *Alpine Landscape*; brush and watercolour and bodycolour on off-white laid paper; 210 x 312 mm. Presented by Chambers Hall, 1855.99

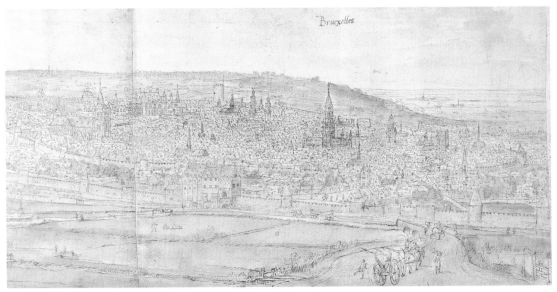

29. Anthonis van den Wyngaerde (*c.* 1525–1571), *Panoramic View of Brussels from the North*, 1558 (detail); pen and brown ink and watercolours over black chalk; 290 x 1275 mm. Presented by Mrs Alexander Hendras Sutherland, 1837, Large Vol. IV, p. 46b

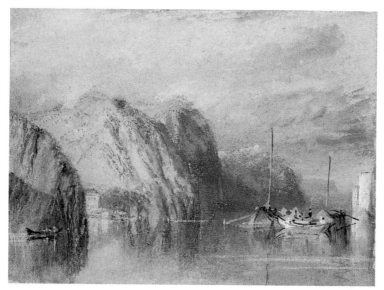

30. Joseph Mallord William Turner (1775–1851), *Between Clairmont and Mauves, c.* 1828-30; watercolour and bodycolour, touched with the pen and with considerable scratching out, on grey paper; 138 x 189 mm. Presented by John Ruskin, 1861.24

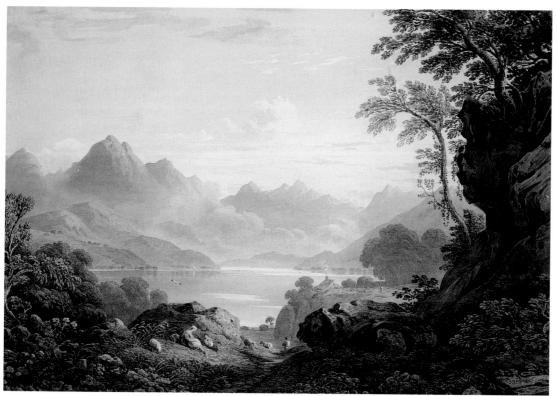

31. John Varley (1778–1842), *View of Upper Lake Killarney*; watercolour over indications in pencil on white wove paper; 277 x 396 mm. Presented by W.V. Paterson through the National Art Collections Fund, 1943.4.19

37

During the 16th and 17th centuries, watercolour was used chiefly for colouring in maps and for tinting topographical drawings (depictions of the natural and artificial features of a district). The *View of Brussels*, 1558, by Anthonis van den Wyngaerde (fig. 29), one of the earliest artists to make topographical drawings, demonstrates a preoccupation with precise and accurate recording. The drawing is given greater clarity and charm by the addition of some light green, pinkish brown and grey wash. In England, as elsewhere in Europe, watercolour has always been closely associated with the art of topography, its heyday beginning in the 1750s and taking its cue from the work of Paul Sandby. By the 1780s, topographical artists such as Thomas Hearne, Joseph Farington, and John Robert Cozens sought to employ more complex techniques of watercolour painting, partly in response to contemporary theories of the sublime and the picturesque (e.g. Edmund Burke's *A Philosophical Enquiry into the Origin of Our Ideas of the Sublime and the Beautiful*, 1757) and the development of the concept of imaginative landscape (e.g. Alexander Cozens's *An Essay to Facilitate the Invention of Landskips*, 1759).

In his *Observations on the Rise and Progress of Painting in Watercolours*, 1812, Rudolph Ackermann considered the development of 'wove' paper by James Whatman in the 1780s to be a central factor in the rise of the British watercolour school. The extremely fine weave of the wire mould resulted in a paper whose fine texture, or 'tooth', could absorb washes more consistently than the earlier laid papers. However, the ascent of the British watercolour school owes a particular debt to the influence of its greatest master, J.M.W. Turner, who inspired many artists of his own and later generations. He exploited the potential of watercolour to achieve a depth of colour and luminosity previously only attained by oil paintings, as well as perfecting techniques such as 'scratching out' dry paint as a means of creating highlights (a method seen clearly in his watercolour *Between Clairmont and Mauves, c. 1828-1830*, fig. 30). John Ruskin argued that in the loose colourful drawings of Turner's later years he was not rejecting the rigour of his topographical training, but rather he was expounding the "far higher and deeper truth of mental vision," creating "the impression which the reality would have produced."

The foundation of the Old Watercolour Society in 1804 and the New Watercolour Society in 1832 gave impetus to the rise of the increasingly popular 'exhibition watercolour'. These societies provided a favourable forum for display instead of the disadvantageous conditions in the Royal Academy, where watercolours were deadened by being placed next to oils or 'skied' by being hung too high to appreciate. One of the sixteen founder members of the Old Watercolour Society was John Varley, whose drawing, *View of Upper Lake Killarney* (fig. 31), sums up the type of visual seduction which epitomised English watercolour in the eyes of later 19th-century commentators, namely bright, translucent washes, picturesque composition and the breath of warm 'Claudian' sunlight throughout.

 # *Gouache / Bodycolour*

Gouache, also known as bodycolour, is watercolour rendered non-transparent by the addition of an opaque white substance, such as white lead (lead carbonate), chalk dust or zinc oxide (the latter was only used from the 19th century). The term 'gouache' was first coined by the French during the 18th century, but the use of bodycolour in Western art long pre-dates that era, as the staple material of medieval manuscript illuminators (see fig. 34). Recipes for making tempera (egg white) bodycolour are included in *De Diversis Artibus* written by the early 12th century monk and craftsman,

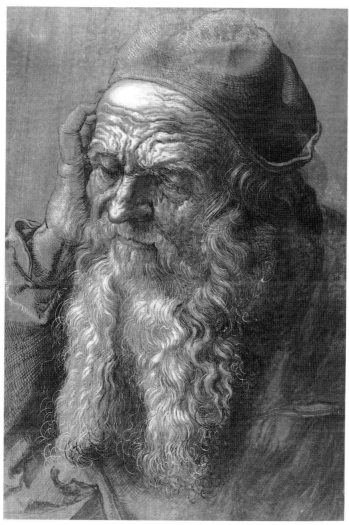

**32. Hans Hoffmann (c.1545/50–1591/2),** *An Old Man aged 93, after Dürer***; brush in black and brown ink, with white bodycolour on a brownish-grey preparation; 391 x 274 mm. Purchased, 1953.118**

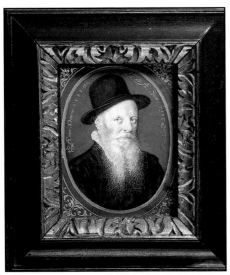

33. Isaac Oliver (1558/68–1617), *Elderly Man in a Black Hat*; gouache (bodycolour) on vellum; oval 61 x 48 mm. Purchased, 1979.72

34. Detail of an historiated initial from a page of a French antiphonal written for the Convent of Beaupré, 1290; Ruskin School Collection, Standard Series 7

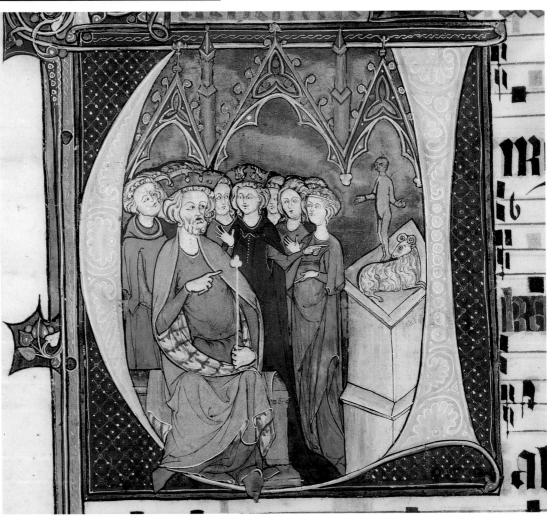

Theophilus (Roger of Helmarshausen), whose book is an invaluable source of information on medieval arts and techniques. Vegetable, mineral or animal extracts would be ground or soaked out and mixed with egg white as well as glue and water, after which white lead, ground eggshell or chalk would be added to increase opacity. The only real difference between medieval recipes for tempera bodycolour and later recipes for gouache was the use of egg white by the earlier artists; otherwise they were essentially the same.

As a result of the decline in manuscript production during the 16th century and the overwhelming preference for painting in oil, bodycolour no longer enjoyed the same prominence as before. However, Raphael's vast tapestry cartoons of *The Acts of the Apostles*, which are part of the British Royal Collection (on loan to the V&A Museum), serve as a famous exception to the general trend. Painted on hundreds of sheets of paper which are stuck together, they can reasonably be described as gouache paintings. Moreover, opaque white or tinted bodycolour remained an essential element in the Renaissance draughtsman's technical vocabulary. It was frequent practice from the 15th century onwards to apply strokes of bodycolour with a fine brush, in order to heighten a drawing in pen and ink, chalk or another medium. On dark papers, or papers with a dark prepared ground, white bodycolour could be used for 'chiaroscuro' drawings, in which figures were defined by prominent applied lights in order to suggest their partial emergence from a deeply shadowed background. Hans Hoffmann's copy of Dürer's drawing, *Old Man, aged Ninety-three* (fig. 32), conforms to these principles. However, the chief strand of continuity in the use of bodycolour, from illuminated manuscript to later centuries, can be found in the art of the painted portrait miniature. From the 16th to the 18th centuries, bodycolour in its full range of colours, was employed almost exclusively by miniaturists, who normally used vellum or ivory for their highly finished portraits. The work of the Elizabethan artist Nicholas Hilliard and his pupil Isaac Oliver marked the real flowering of miniature painting (see fig. 33).

Gouache enjoyed something of a rediscovery in the 18th century, as a result of the growing interest in watercolour. Once artists had mastered the transparent technique, it was natural for innovators such as J.M.W. Turner to explore the characteristics of opaque pigment to emphasise contrasts (see *Between Clairmont and Mauves*, fig. 30). In 1834 Winsor & Newton introduced their newly patented "Chinese White" made of zinc oxide, which according to its inventor's advertising, caused a revolution in English technique. Now more than ever, it was possible for watercolourists to emulate the effects of oil painting. The Pre-Raphaelites were particularly noted for their interest in the 'oil' watercolour manner. The Memorials of Edward Burne-Jones record an occasion in 1875 which shows how skilled they were at manipulating their medium. John Ruskin and Cardinal Manning were inspecting an oil painting by Edward Burne-Jones. With mercurial delight Ruskin teased the hapless Cardinal by saying 'Pure water-colour, your Eminence.'

#  *Drawing Supports*

## Parchment

Parchment is the generic term for animal skins, which have been stretched, treated and dried in order to provide a flat sheet. It is commonly made from sheepskin, goatskin or calfskin. Strictly speaking the term 'vellum', often used for finer parchment, only applies to skins made from calves. The finest of all parchment was that made from the skins of foetal animals. Normally the pelt would be soaked in lime for up to ten days to remove the epidermal layer. After the hair had been cut off and the skin washed, it would be tightly stretched on a wooden frame and left to dry in normal temperatures. Finally, in order to acquire a smoother surface the skin would be worked over with pumice stone. During the Middle Ages, parchment was the principal support for writing, painting (in manuscripts), and drawing (for example model books used in illuminators' workshops). It was also often used for bookbinding. The use of parchment declined from the mid-15th century, once paper became more widely available in Europe.

## Paper

Paper was invented in China in the 2nd century BC during the Western Han period (206 BC – 9 AD) and probably first spread to Japan in the 4th century AD. Already by the Heian period in Japan (794-1185), papermakers had become so skilled at the art that they could make thin papers deco-

rated with flower petals and leaves, for which Japan is so famous. Such fine, yet strong East Asian papers have never been equalled by Western papermakers. According to an 11th-century account, the secret of how to make paper was only divulged outside East Asia in 751 AD, when the Muslims captured Chinese papermakers in a battle fought on the banks of the Talas River near Samarkand in Western Central Asia. Thereafter, papermaking spread through the Muslim world, including Sicily and Southern Spain, where the first European paper mill was established in Játiva in the 11th century. By 1276, a paper mill was operating at Fabriano in Italy and by the end of the 14th century, Italy and France had become well established as the chief paper making countries of Europe. It is remarkable that the use and manufacture of paper took so many centuries to be established in the West.

The finest early European paper was made from white linen rag, but hemp was also used for coarser paper. By the 18th century cotton rag had also been introduced to paper manufacture, but wood pulp was not used until the early 19th century. The shredded linen, hemp or cotton fibres would be made into a liquid pulp, contained in a large vat, at which at least two papermakers would work in partnership. The mould for the paper was composed of a fine wire grid of laid lines (horizontal lines, very close together) and chain lines (vertical lines, between 20-50 mm apart depending on the mould), which was held in a frame called a

deckle. Two moulds were needed at any one time. The first man would dip the mould into the vat, covering it thinly and evenly all over. He would then release the mould from his deckle, handing it to the second man, who would turn over the raw paper onto a piece of felt. As the second man gave back the mould to the first, he would receive the other mould to turn the paper out onto the felt, and so on. Once a stack of paper, interleaved with felt had been made, it would be put in a press. Raw paper is absorbent like blotting paper, so the sheets needed to be 'sized' by soaking them in lime water (later warm gelatine was used), after which they would be hot pressed and sometimes polished with pumice stone to flatten impurities. Lightly sized paper (more absorbent) was generally used for printing because printing ink was oil based, whereas hard sized paper was better for writing and drawing because the inks were water based. The paper moulds would also normally include a wire design, such as an ox head, a crown, a family seal or a hand, which would make the paper thinner in that area, hence more translucent, and thus create a watermark (fig. 35). Watermarks can provide invaluable information for dating and locating the paper source, but the evidence needs to be interpreted carefully, since, before the 18th century at any rate, watermarks tended to denote size or quality rather than signifying a particular paper mill.

Paper began to be more widely available in the years following Johannes Gutenberg's invention of movable type *c.*1440, in Mainz in Germany. As a consequence of the burgeoning printing industry, demand for

**35. Watermark, *Gallizian seal*; Italian paper made in Lombardy at the paper mill of the Gallizi family, *c.* 1475-80; 46 x 13 mm; chancery sheet; used by Martin Schongauer for the impression of his engraving, *The Whipping of Christ*, L.22, Ashmolean Museum.**

paper greatly increased, with the result that many more paper mills were established across Europe during the 15th and 16th centuries. It was probably also at this time that paper sizes began to be roughly standardised because of the demands of printers. At the end of the 15th century, Venetian papermakers began to experiment in making blue paper, by using coloured rags and soon a range of grey and fawn coloured papers followed.

However, papers specifically designed for drawing (especially for watercolour and pastel) were not made until the mid-18th century in England. In 1750, James Whatman invented 'wove' paper at his Mill in Maidstone, Kent. The mould was composed of a very fine woven wire mesh and yielded a beautifully even textured paper. At first the paper was sized for printing, but as the market for watercolour papers grew in the 1780s, not only due to the demand from professional artists but also from the increasing number of educated, middle class amateurs (both men and women), Whatman's wove paper was developed into stout, hard-sized sheets, suitable for the demands of wetting and rewetting in watercolour, without damaging the paper. Papers with mottled textures also began to appear, made by impressing the texture into the surface of the wet raw sheet. They were sought after by artists who wished to explore the qualities of light and half-light which reflected through the transparent watercolour according to the rise and fall of the paper surface. It was not until 1804 that a machine for making continuous paper was perfected by the English family of stationers, Fourdrinier, but artists' manuals warned draughtsmen away from machine-made paper, not only because it was badly sized, but also because the wood pulp from which such paper was made contained high levels of acidity and quickly became brittle and discoloured.

# Glossary of Terms

**Black chalk** A naturally occurring form of carbonaceous shale, which was first used for drawing in the 15th century, but the lodes had been mined out by the end of the 18th century.

**Binder** The term for a glue, gum or other substance which is used to make the ingredients of materials such as fabricated chalk, pastel, crayon, watercolour or bodycolour cohere.

**Bistre** An ink made from the soot of a wood-burning fire, which is characteristically warm brown in colour.

**Bodycolour** Also known as *gouache*. Opaque paint made by mixing a pigment with lead white or zinc oxide and a binder. White bodycolour was often used for heightening.

**Boxwood tablet** Thin panels of close-grained boxwood, which were used until about the mid-15th century for experimental drawing. The surface had to be prepared with a ground, which could be scraped off and re-applied in order to reuse the tablet.

**Brush** A body of hairs, usually squirrel, stoat, weasel or sable hair, which was set either in a quill or in a metal ferrule with a wooden handle, and used for drawing in wet media such as ink, wash and watercolour.

**Carbon ink** A stable black ink, derived from ancient Chinese recipes, usually made from the soot of burning oils or resins (lampblack).

**Cartoon** A preparatory drawing for a painting or fresco, made on the same scale as the finished work, so that the design can be transferred by means of *pouncing* onto the final support.

**Chalk** See *Black chalk, Red chalk, White chalk*

**Charcoal** A friable drawing stick, made by slowly heating twigs, commonly willow, in an airtight chamber. This carbonises the wood without turning it to ashes. Charcoal is greyer than black chalk and was often used for underdrawing because it is easily erasable.

**Conté crayon** A type of fabricated chalk or graphite pencil, made in varying degrees of hardness according to the proportion of clay included in the mixture. The process was invented by Nicholas Jacques Conté and was patented in 1795.

**Contract drawing** A drawing submitted by the artist to a patron in order to secure a commission for a work of art.

**Counterproof** A print from a red chalk drawing, which is taken by placing a dampened sheet over the drawing and running them together through a roller press. Under pressure loose chalk from the surface of the original drawing is transferred to the dampened sheet, creating a reversed image. Counterproofing was a popular practice among French artists making drawings for prints in the 18th century.

**Crayon** A fabricated drawing stick like chalk, but made with a fatty or greasy binder such as wax, which gives a sleek appearance to the strokes.

**Deckle** The frame in which a papermaker holds the mould on which the paper is made.

**Draughtsman** An artist who makes drawings.

**Fabricated chalk** Also known as *pastel*. Made by mixing dry pigments with a binder to make a paste, which is rolled into a stick and dried. Probably first made in the late 15th century, but the heyday of fabricated chalk and pastel was the 18th and 19th century, especially in France.

**Fixative** A protective finish applied to a drawing in a dry medium such as pastel or chalk. Modern fixatives are made from synthetic resins in solvents and are applied as a spray, but earlier methods included dipping the drawing in a gum bath and allowing it to dry, brushing over the surface with diluted egg white or fig juice and, for red chalk drawings, counterproofing.

**Friable** An adjective, meaning soft, dry, crumbly, loose, chiefly used to describe the qualities of charcoal and some textures of chalk and pastel.

**Gouache** See *Bodycolour*

**Graphite** A crystalline form of carbon which has a metallic sheen in appearance. Pure graphite, suitable for drawing, was found in Cumbria in northern England in the 16th century. By the 18th century milled graphite extracted from less pure sources was used in combination with china clay (See *Conté crayon*).

**Ground** The term used for a mixture of ground bone or egg shell combined with glue water which was then applied to a drawing support in order to give it a smoother surface or a background colour.

**Gum arabic** The water-soluble gum from an acacia tree, which artists have used since the middle ages as a binder for many different drawing media. Watercolour paints are bound in gum arabic to ensure that the pigment adheres to the paper once the paint has dried.

**Heightening** The term used for highlights applied to a drawing with white chalk or white/tinted bodycolour.

**Ink** See *Bistre, Carbon ink, Iron gall ink, Sepia*

**Iron gall ink** Ink produced by a chemical reaction between tannic acid (extracted from gall-nuts) and a solution of iron sulphate. It was the most common of all inks until the 19th century, but it is chemically unstable with the result that it turns from being black to becoming brown over a period of years.

**Leadpoint** A type of metalpoint. Lead is soft enough to leave a mark on unprepared paper, so it was often used for the preliminary indications of a drawing executed in a more permanent medium.

**Metalpoint** The generic term for any metal, such as silver, lead, copper or gold cast into a stylus and used for drawing. Metalpoint was common in the 15th and early 16th century and had to be used on prepared paper.

**Opaque white** Non-transparent white bodycolour which was made from lead white or chalk powder, until zinc oxide was introduced as 'Chinese white' in the 19th century. It was used both for heightening drawings and for adding to watercolour in order to make bodycolour.

**Paper** A drawing support made by hand on a wire mould from the liquid pulp of shredded linen or cotton rag (for finer paper) or hemp (for coarser paper). Its manufacture became widespread in Europe during the 15th century. However, machine-made paper from wood pulp was introduced only in the early 19th century.

**Parchment** The generic term for animal skins, such as calf, sheep or goat skin, which have been stretched, treated and dried in order to provide a flat surface for writing, drawing or painting. The use of parchment began to decline after paper became widely available in the 16th century.

**Pastel** See *Fabricated chalk*. During the 18th and 19th centuries the term 'pastel' became closely associated with the softest types of fabricated chalk used in highly coloured 'pastel paintings'.

**Pen** A drawing instrument with a nib which, when dipped in ink gradually releases the fluid as the pen moves. Ancient Egyptian pens were made from reeds, but from about the 6th century pens were usually made of swan, goose or crow quills (feathers). During the 19th century pens with metal nibs became common.

**Pencil** Originally the term referred to a paint brush. However, by the end of the 17th century the term began to be applied to a thin strip of graphite encased in wood, which is its common meaning today.

**Pigment** Vegetable, mineral or animal extracts which act as the colouring agent in paint.

**Pouncing** The practice of pricking holes along the outlines of a cartoon, through which charcoal dust is blown or 'pounced' in order to transfer the outlines of the image onto the final support of the work of art e.g. the wet plaster of a fresco.

**Presentation drawing** A term first used in the 1950s to describe highly finished drawings by Michelangelo. It has since been applied to any drawing which is a finished work of art in itself.

**Rabbit skin glue**  Glue made from the skin of rabbits.

**Recto**  The front or more fully worked side of a drawing. In a bound volume the recto is always the right hand page of an opening.

**Red chalk**  A naturally occuring chalk of haematite (iron oxide) suspended in clay. This was one of the most favoured drawing techniques during the Italian Renaissance, but by the end of the 18th century supplies of natural red chalk had been exhausted.

**Sanguine**  A French term for red chalk, whether natural or fabricated, used from the late 17th century onwards.

**Scratching out**  A technique developed by 19th-century English watercolourists for creating highlights by scratching off dried paint and in so doing exposing the roughened fibres of the paper.

**Sepia**  An ink made from the dark brown liquid in the ink sacs of cuttlefish (and squid) and generally used for wash drawings. The term is often misused – genuine sepia was hardly known before the 19th century.

**Silverpoint**  The most common form of metalpoint, used in the 15th and early 16th centuries. Silverpoint had to be used on paper prepared with a ground in order to make a mark. The thin deposit would oxidise in the air to form a pale grey line.

**Sizing**  The treatment of raw paper, by dipping it in lime water or warm gelatine (a later method), in order to make the paper less absorbent and hence suitable for drawing, writing or printing.

**Stump**  A tightly wound coil of leather or paper, which tapers to a blunt point at both ends and was used instead of the fingers to rub chalk, pastel or charcoal, thereby creating a softer appearance.

**Stylus**  See also *Metalpoint*. A drawing instrument, usually of cast metal (commonly silver), which has a point at each end. Cheaper styluses were made of wood, with a metal point attached.

**Tempera**  A very old type of paint, particularly used in illuminated manuscripts. It is essentially the same as bodycolour, but the pigments are suspended in egg white (distemper).

**Trois crayons**  A technique using black, red and white chalk, where each colour retains its independence in the composition, developed in the 18th century by the French artist Antoine Watteau.

**Underdrawing**  The term used for any preparatory drawing on the support of a finished work of art. Charcoal and leadpoint were the most common media used for underdrawing.

**Vellum**  A type of fine parchment made from calf skin.

**Verso**  The back or less highly worked side of a drawing. In a bound volume the verso is always the left hand page of an opening.

**Wash**  Diluted ink applied with the brush in order to indicate the modelling of form or the direction and intensity of the light.

**Watercolour**  Finely ground dry pigments, which are suspended in water with gum arabic as a binder. Watercolour is translucent and acquires its luminosity from the reflection of light off the white paper through the pigment and back to the eye.

**Watermark**  A translucent design in the structure of a sheet of paper denoting its size, quality or origin, made by weaving a wire device into the paper mould so that the paper is thinner in that area and hence more translucent.

**White chalk**  Calcite is the most common form of natural white chalk, still in plentiful supply. It was used for heightening drawings, or if ground to a powder, it could be used to make bodycolour or grounds for paper.

 # *Suggestions for Further Reading*

One of the most helpful and detailed books on drawing techniques is J. Watrous, *The Craft of Old Master Drawings*, Madison, the University of Wisconsin Press, 1957. It is particularly thorough in describing the chemical composition and characteristics of different drawing media. For a more historical perspective on old master drawing, F. Ames-Lewis, *Drawing in Early Renaissance Italy*, New Haven & London, Yale University Press, 1981, is highly recommended. S. Lambert's short exhibition catalogue *Drawing: Technique and Purpose*, London, Victoria & Albert Museum, 1981, is imaginatively written and full of useful information. There are a number of interesting articles, especially on red chalk, in W. Strauss and T. Felker (eds), *Drawings Defined*, New York, 1987. Invaluable for information on watercolour and bodycolour is M.B. Cohn's book *Wash & Gouache: A Study of the Development of Materials of Watercolour*, Cambridge MA, Fogg Art Museum, Harvard University, 1977. There is also a good exhibition catalogue by C. Nugent, *From View to Vision, British Watercolours from Sandby to Turner in the Whitworth Art Gallery*, Manchester, The Whitworth Art Gallery, 1993, which explores the way in which ideas about watercolour painting developed in Britain during the 18th and 19th centuries. Among the other books which specialise in one particular technique, G. Monnier, *Pastels from the 16th to the 20th Century*, Geneva, 1984, should also be noted. For the reader wanting a guide to terms, P. Goldman's beautifully illustrated book *Looking at Prints, Drawings and Watercolours, a Guide to Technical Terms*, London, British Museum in association with the J. Paul Getty Museum, Malibu, 1988, is ideal. Relevant entries in *The Dictionary of Art*, (ed.) J. Turner, 34 volumes, Grove's Dictionary, Macmillan Publishers, 1996, are also well worth looking up.

For the reader who is interested in going back to original sources, an alphabetical list of all the primary works referred to in the text of this book follows: Ackermann, Rudolph, "Observations on the Rise and Progress of Painting in Watercolours," *The Repository of Arts, Literature, Commerce, Manufactures, Fashions and Politics*, vols. 8-9, London, 1812-13; Baldinucci, Filippo, *Vocabolario Toscano dell'Arte del Disegno*, Florence, 1681; Burne-Jones, Georgiana, *Memorials of Edward Burne-Jones*, 2 vols., New York, 1904; Cennini, Cennino, *Il Libro dell'Arte*, c. 1390, modern edition, Vincenza, 1971; Gregorius, Petrus, *Syntaxeon artis mirabilis*, Cologne, 1583; Hochheimer, C.F.A, *Chemische Farben-Lehre*, Leipzig, 1797; Hoogstraeten, Samuel van, *Inleyding tot de Hooge Schoole der Schilderkonst*, Rotterdam, 1678; Jombert, Charles-Antoine, *Methode pour apprendre le dessin*, Paris 1755; Langlois de Longueville, F.P. *Manuel du Lavis à la Sepia et de l'Aquarelle*, Paris 1830; Leonardo da Vinci: C. Pedretti, *The Codex Atlanticus of Leonardo da Vinci, A Catalogue of its Newly Restored Sheets*, New York, 1978-9; Lomazzo, G.P. *Trattato dell'arte della pittura, scoltura et architettura*, Milan, 1584, modern edition (ed) R. Ciardi, 2 vols, Florence, 1973-4; Lomet, A.F. "Mémoire sur la fabrication des crayons de pâte de sanguine employés pour le dessin" *Annales de Chimie*, 1st series, vol. 30, Paris, 1799; Theophilus, *De Diversis Artibus*, c. 1110-1140, modern edition *Nelson's Medieval Texts*, (ed. and trans.) C.R. Dodwell, 1961; Vasari, Giorgio, *Le Vite De'Più Eccellenti Pittori, Scultori e Architettori*, 1550, 2nd ed. 1568, English translation, G. Bull, *Lives of the Artists*, Penguin Classics series, 3rd reprint, 1987; Volpato, Giovanni Battista, *Del preparare tele, colori ed altro…aspettante all'pittura*, Bassano, 1847.